W9-AUY-234

ICE CAVES OF LEELANAU

A Visual Exploration by Ken Scott

With an essay by Jerry Dennis

LEELANAU PRESS

The Leelanau Press and Ken Scott wish to thank
underwriters Tom and Burma Powell, Art's Tavern
in Glen Arbor, The Business Helper, LLC, in
Suttons Bay and *The Leelanau Enterprise*. Their
generosity has made this publication possible.

Published by Leelanau Press, a nonprofit press,
Box 115, Glen Arbor, Michigan 49636, 231-334-4395,
siepker@aol.com, leelanaupress.com

Photography ©2014 Ken Scott
Essay ©2014 Jerry Dennis

Thank you to Ernie Ostuno, meteorologist, from
Grand Rapids, Michigan, for image descriptions.

ISBN 978-0-9742068-5-1
First Edition, 3rd Printing, 2014
Book Design by Saxon Design Inc.
Printed in Canada

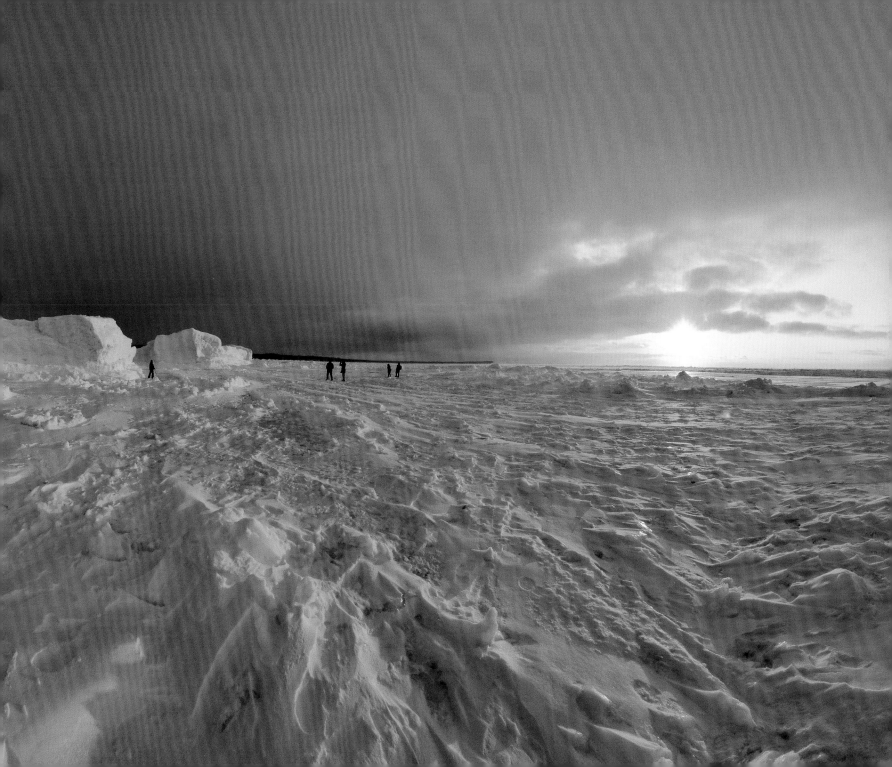

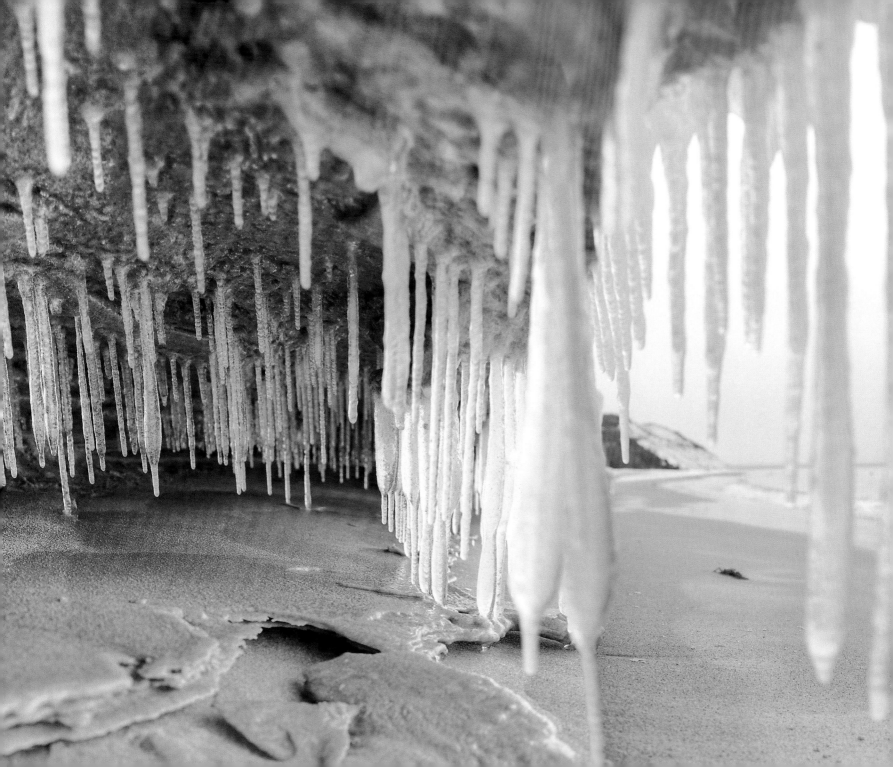

A Winter of Ice and Cold *by Jerry Dennis*

We were only a few weeks into the winter of 2013-14 when we started thinking it might turn epic. Even in December it reminded us of the winters we remembered from childhood, when temperatures often fell below zero and plows couldn't keep up with the snow. Then came February and it started to get epic indeed.

A meteorological term entered our lexicon: polar vortex. The weather guy explained that the arctic jet stream was looping farther south than usual – much farther south – and with it came a circling vortex of frigid air that usually stayed above Baffin Island and Siberia. It descended over the Great Plains and the Great Lakes, bringing snowstorms and subzero temperatures. Schools closed; records started falling. Most of the eastern half of the United States felt the bite. It was the Arctic come down to visit.

And then the Great Lakes froze over. Not just the bays – that was rare enough – but the big water, the wide-open. Many of us remembered the severe winters of the late 1970s, when storms paralyzed the continent and Great Lakes ice was extensive. In the winter of 1976-77 a total of 93.1 percent of Lake Michigan froze over, setting a record many thought would stand forever. But in 2014 it was broken – barely, but still – with 93.3 percent.

It began early, in December, with ice anchoring in the sand and gravel at the edges of the lake and forming an ice foot. Waves struck it and threw spray that froze and added new layers. A ledge formed – brilliant white because of the air trapped inside and smooth as wax from the waves washing over it.

As the waves struck, some of their force went under the ice. You would see a wave break against the ledge and a moment later hear throbbing and booming underneath. If the water found a fissure it would force its way through and burst into the air in a spout. Around every spout-hole grew cones of ice ten or fifteen feet high. A wave would strike – and a beat later a white volcano would erupt.

Ledges grew into ramparts and castles. Waves shoved plates of blue ice the size of patios onto the ramparts, and breaking waves coated them in white. The waves were doing other work, as well. They burrowed into every opening in the ice, excavating small chambers into bigger ones, enlarging and smoothing until they formed smooth-walled caves opening onto the lake.

The caves were the surprising thing. Many of us had seen similar structures during other winters, but never many of them, and never this large. These were big enough to stand in – for a dozen people to stand in – and as elaborate as caves in

limestone. They were domes and keyholes and grottos. Wave spray and intermittent thawing and freezing had embellished them with columns and pillars. Their surfaces were so smooth they gleamed in sunlight, and from their ceilings dripped hundreds of daggers of clear ice, like crystal stalactites.

The lake got colder. The near-shore wash was thick with slush, with balls and plates of ice banging against each other. Then it froze into aggregate. Farther out, sheets of clear ice froze, but waves came and shattered them and threw the pieces into the aggregate. A wasteland of jumbled ice grew to the horizon, around the islands, and across to Green Bay. It spread southward, past the Manitous and Point Betsie, down the shore and across the widest spot in the lake – 118 miles of open water to Wisconsin – then to the bottom of the lake at Chicago.

In February news of the Leelanau ice formations went viral. Facebook and Twitter spread the story first, followed by the mainstream media. One weekend 5,000 people showed up, creating traffic jams that forced the sheriff to close Gill's Pier Road. After that people had to walk two miles to see the ice – and still they came by the hundreds. Many of them poured into Fischer's Happy Hour Tavern on M-22, where the hottest item on the menu was the Cave Burger.

The photos that went around Facebook the rest of the winter were stunning. Many of the most stunning of them were by Ken Scott. Ken was not the first to document the phenomenon, but there's no doubt he did the most thorough job of it. If you can call it a job. Ken makes his living with his camera – and works day and night, in every season, to do it – but he's never lost the spirit of play. He'll sit for hours waiting for the light to make some subtle switch, then fling himself into it laughing. I've seen him dive to his belly to get a close-up of something on the ground, then roll over onto his back to examine what the sky looks like from that vantage. Sometimes he cuts loose with wild, panoramic volleys from his camera, as if firing flowers at the world.

We're lucky to have him on the job. And lucky that he was here to document the events of this remarkable winter. I'm certain we'll be talking about this winter of ice and cold – and Ken Scott's artistry – for many, many years.

JERRY DENNIS, a northern Michigan icon, is noted for his outstanding nature writing. Jerry has been a professional writer for thirty years and has published a dozen books in addition to many essays.

Jerry Dennis touring anchor ice ledges in March, 2014.

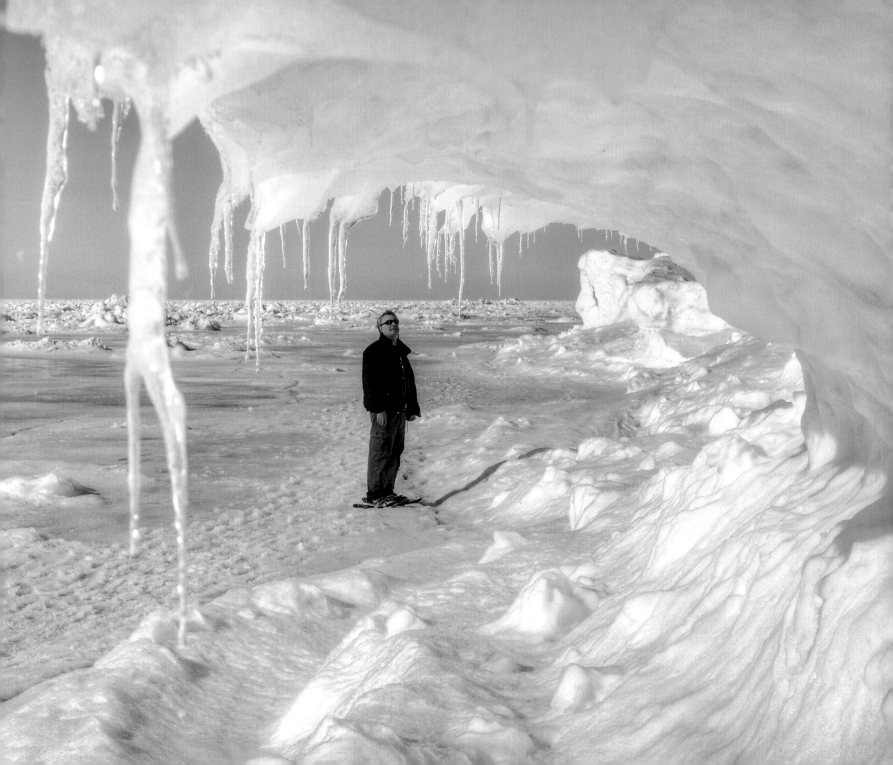

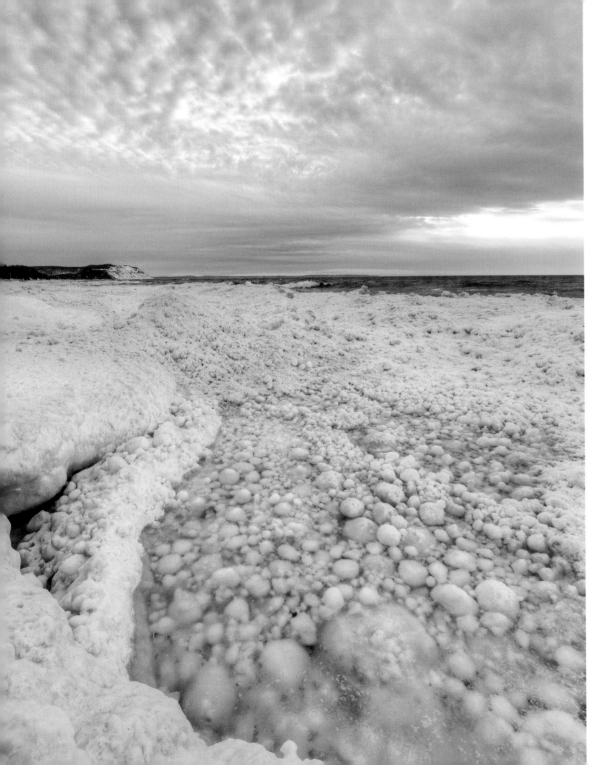

ICE BALLS AND ANCHOR ICE

Ice balls are formed by the accretion of small chunks of floating ice tumbled around by wave action. Anchor ice, or shore ice, forms when large chunks of ice become beached on the sand near the shore, usually on sandbars. These chunks grow into mounds as water from waves freezes on them. Gaps in the mounds occur where the sandbars are eroded by strong, shore-parallel currents. These gaps may be partially filled in over time through accretion of ice from waves. The center photo shows accumulation of ice balls in a gap in the anchor ice.

The photo on pages 28 and 29 shows how big the anchor ice can get, and how it can crack and calve as it settles into the sand on which it rests.

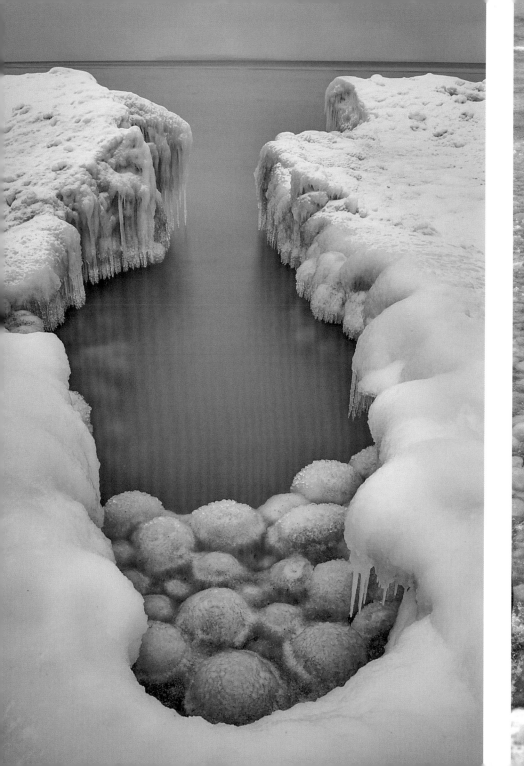
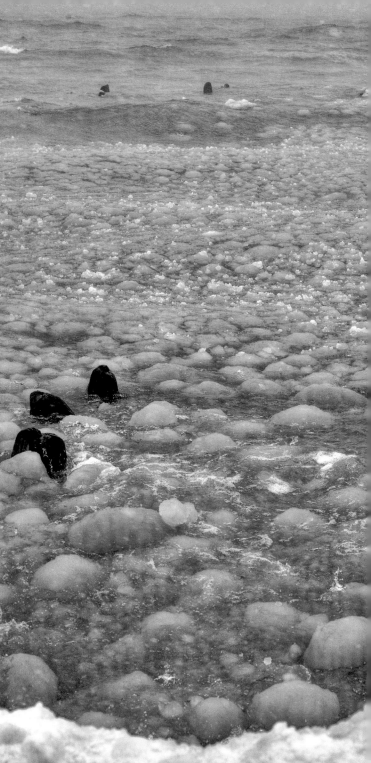

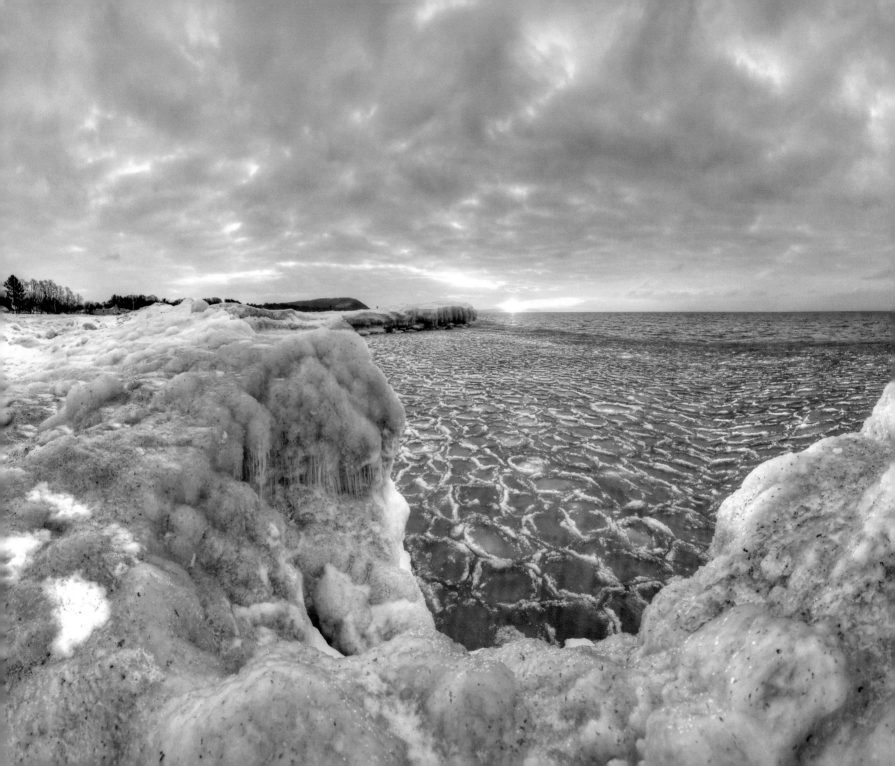

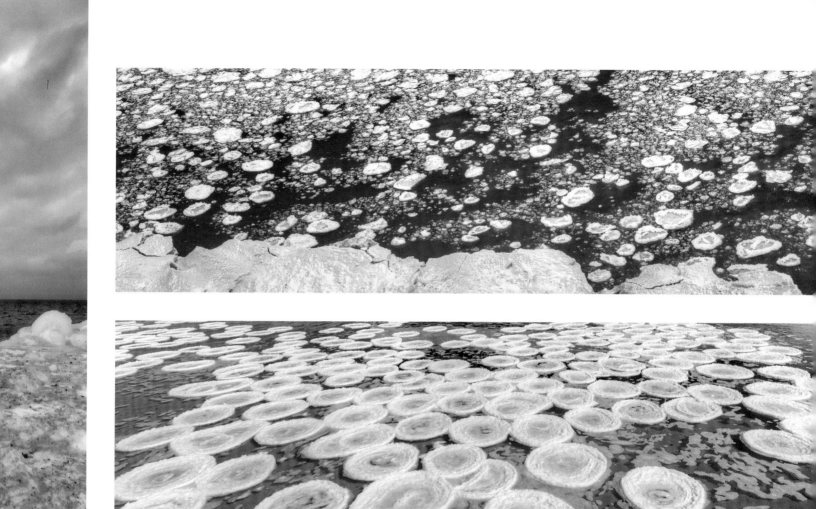

PANCAKE ICE AND PACK ICE

Flat chunks of floating ice with rounded edges and slightly raised rims are called pancake ice. They form as ice chunks a few inches to several feet in diameter continuously bump into each other. In the photo on the left they have congealed into a solid mass of floating pack ice. The pack ice is often fractured and moved around by currents generated by strong winds.

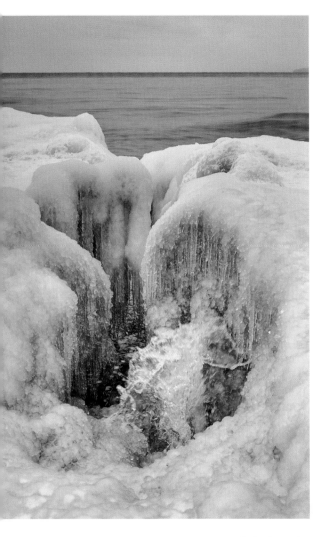

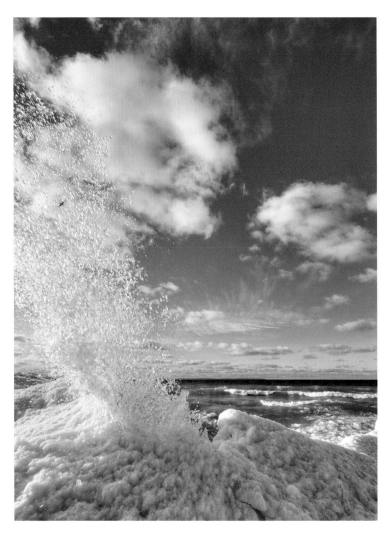

VOLCANO FORMATIONS

Gaps in anchor ice gradually fill in as waves spray water on all sides, eventually forming a hollow volcano. During prolonged periods of extremely cold and windy weather, the mounds and hollow areas can grow into ice caves.

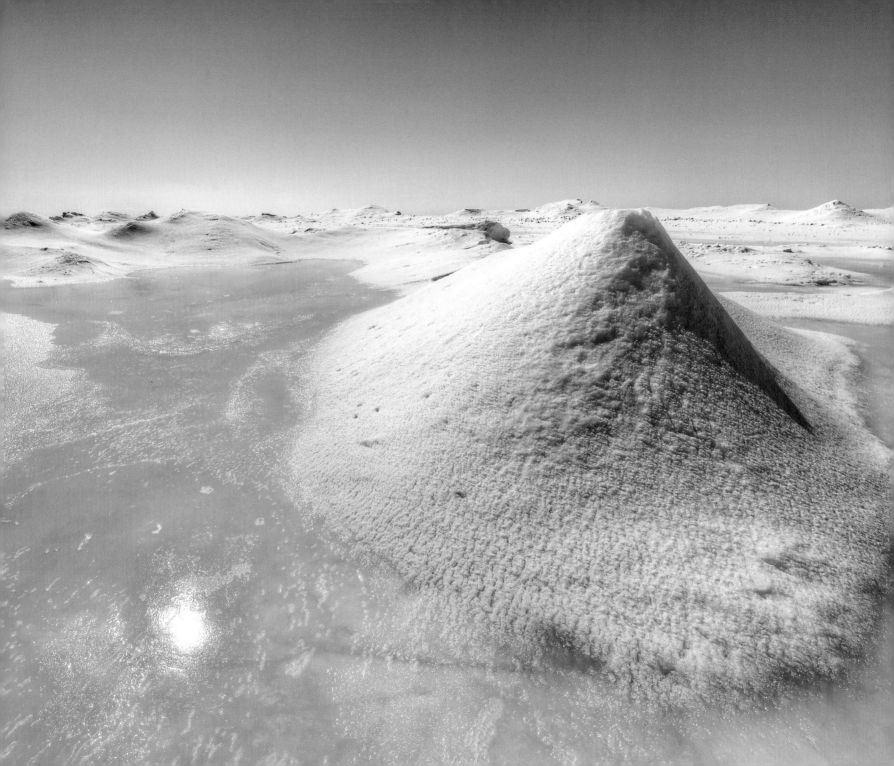

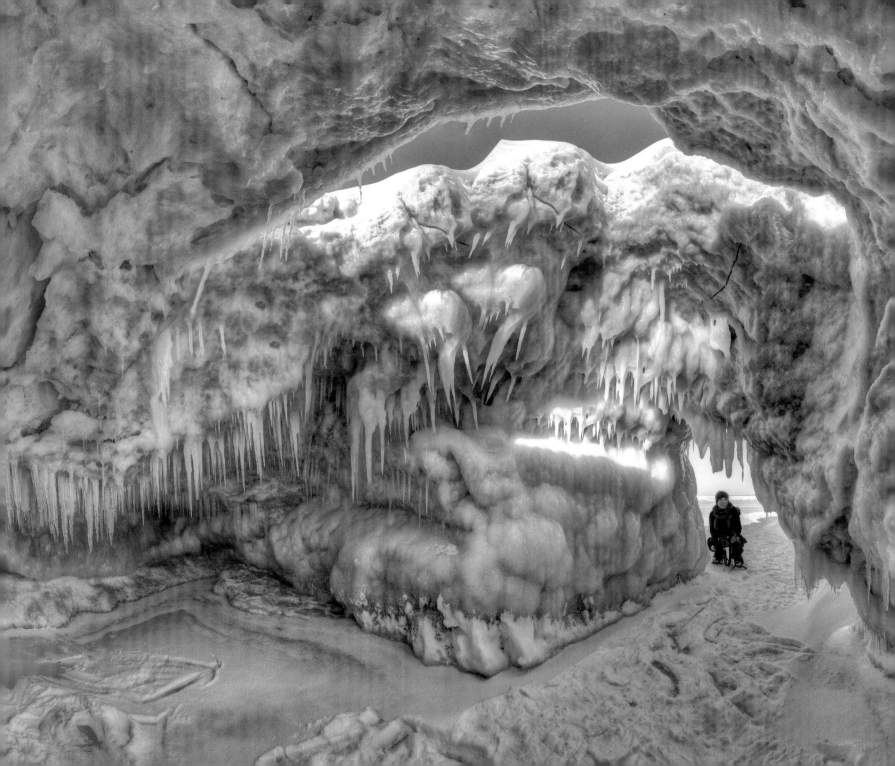

CAVE FORMATIONS

Ice caves are larger versions of ice volca-
noes and they form in generally the same
way. Within some ice caves the volcanic
holes can still be seen.

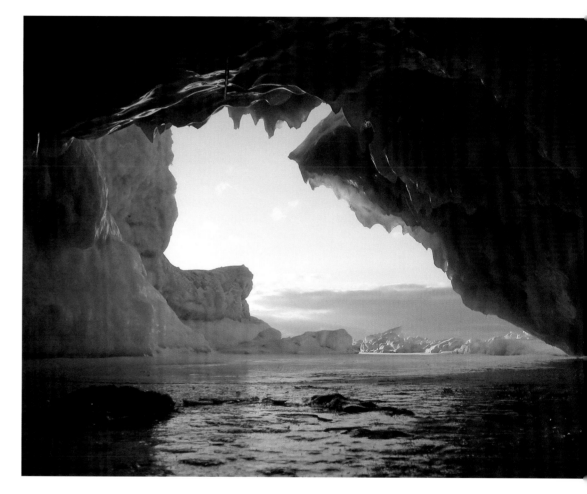

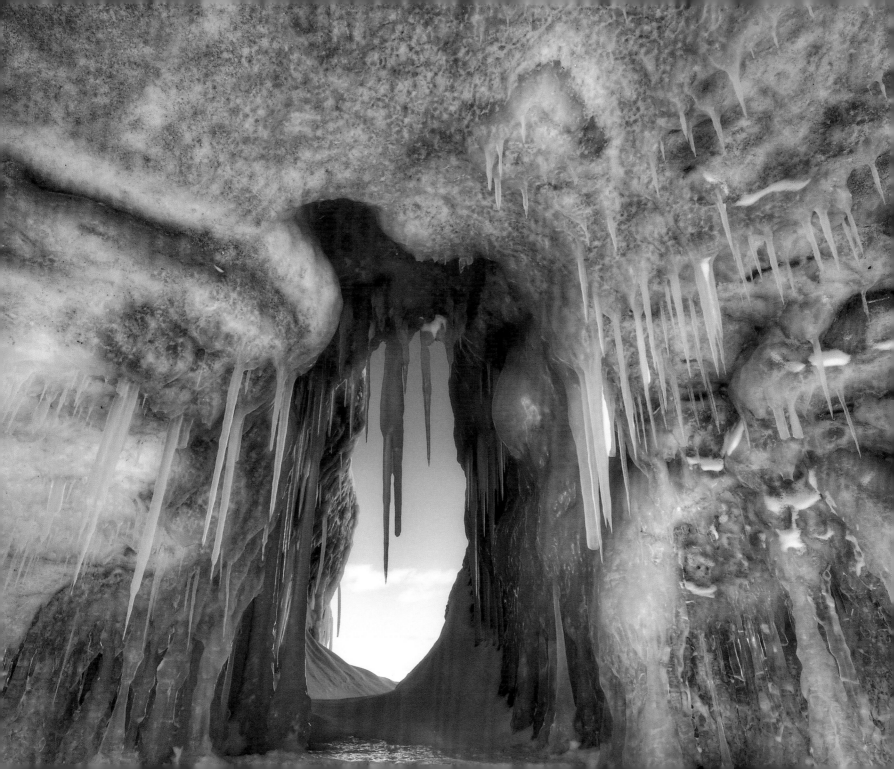

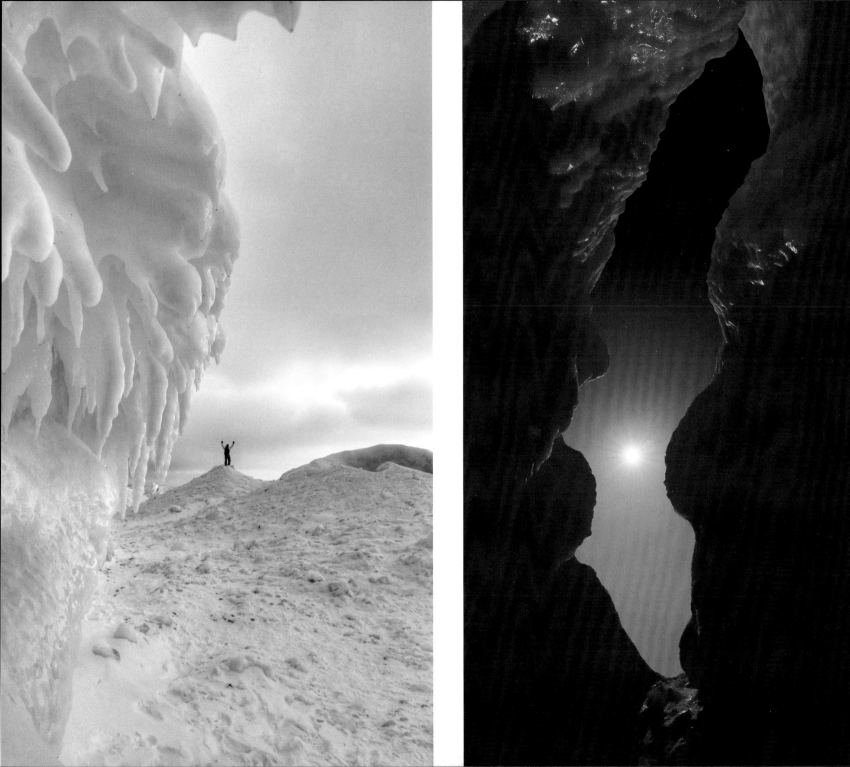

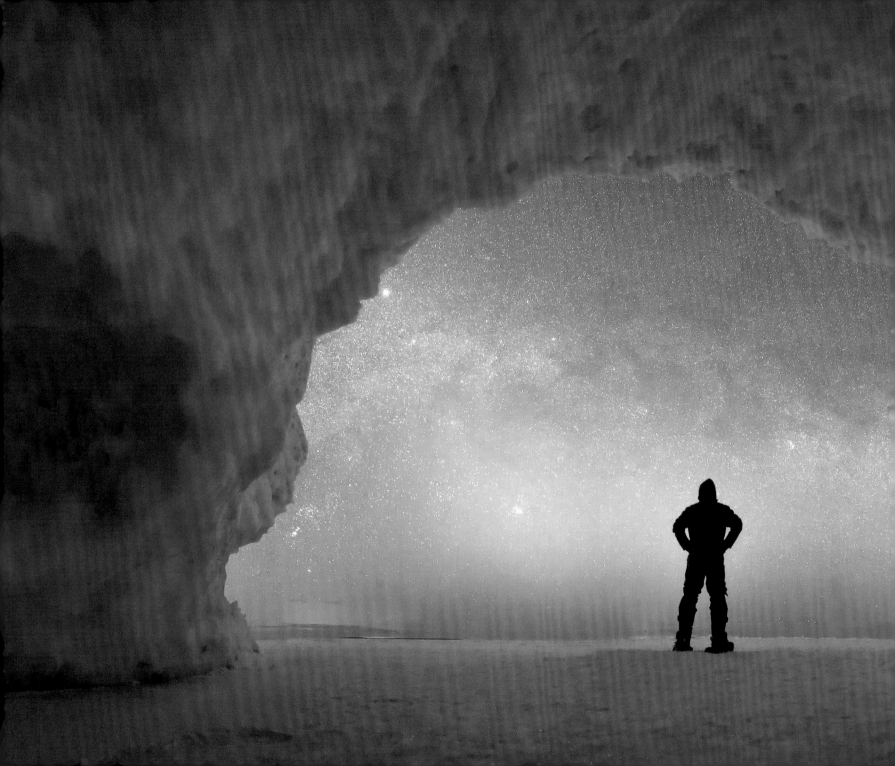

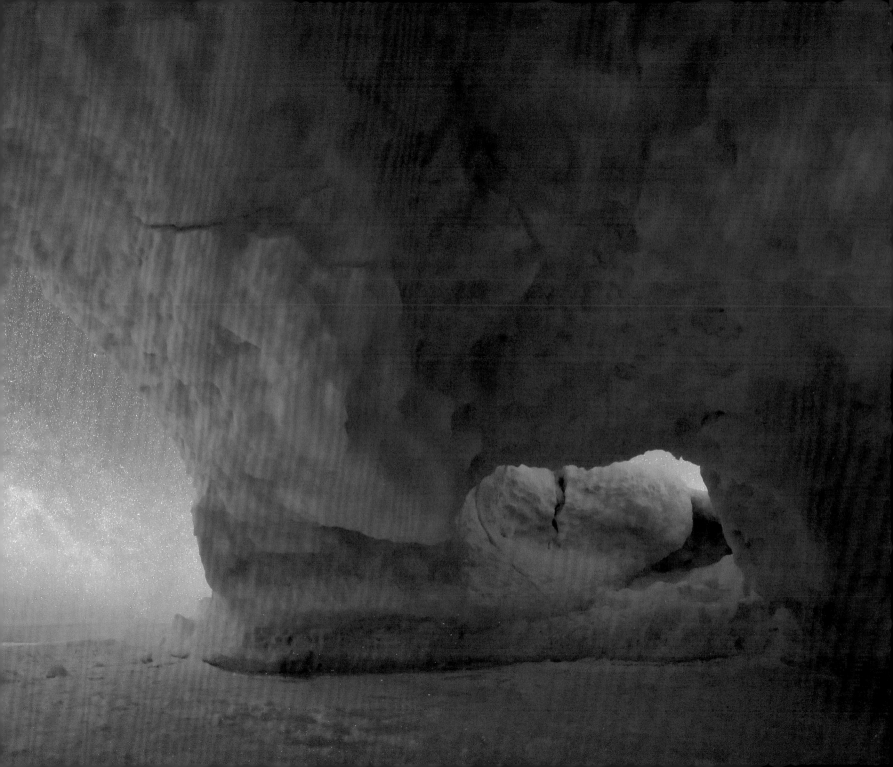

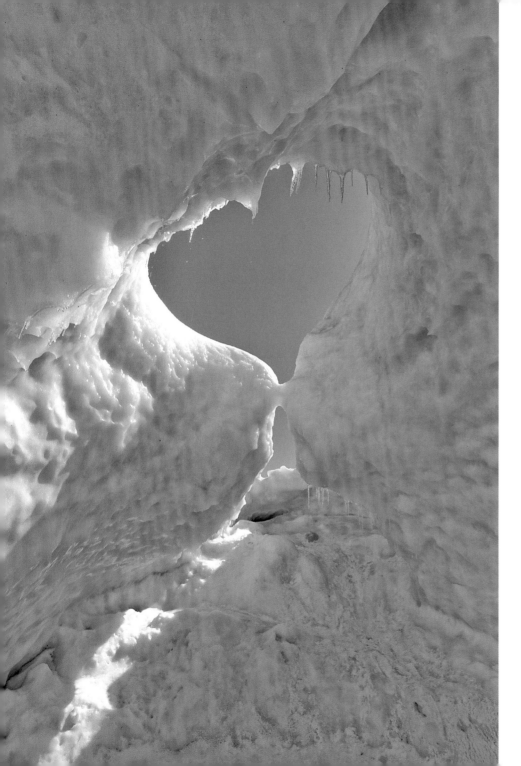

SHAPES IN THE ICE

Layered ice comes in a variety of shapes and sizes attesting to the artistry of Lake Michigan's ice machine.

The photo on the right shows star and earth movement and a hint of the Aurora Borealis or Northern Lights recorded using time-lapse photography.

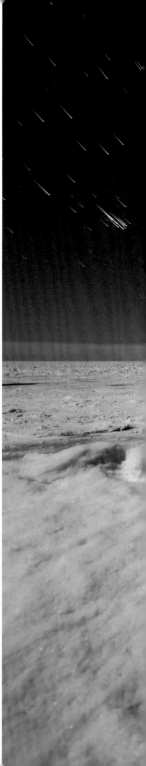

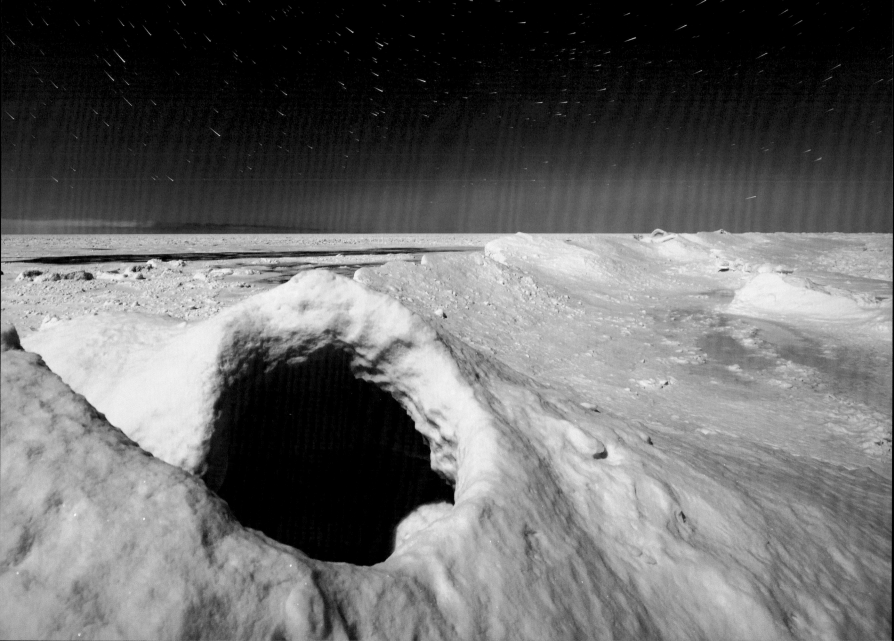

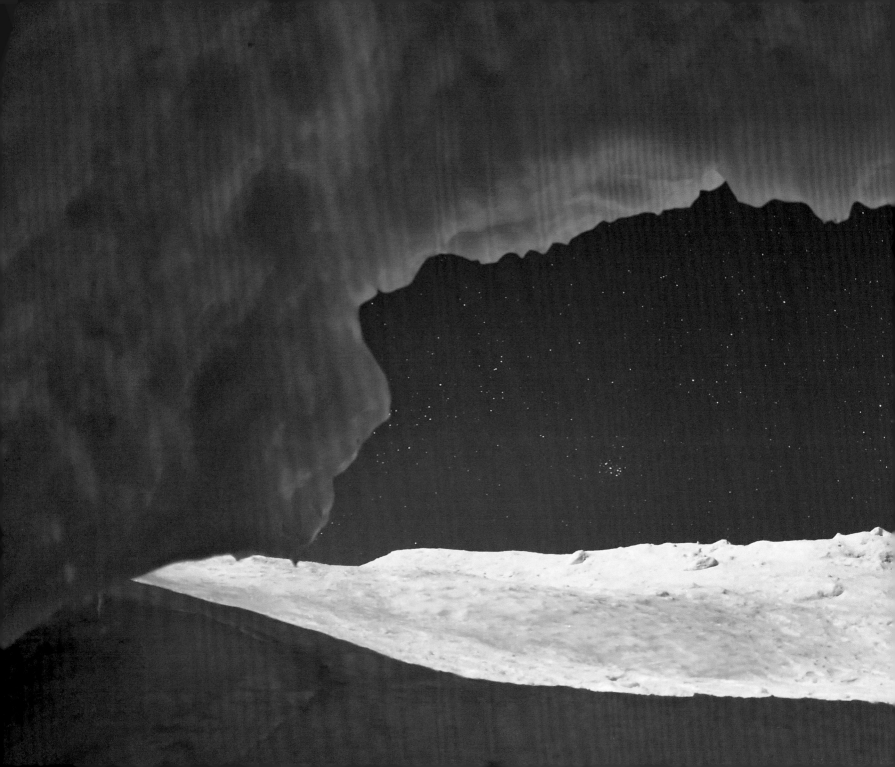

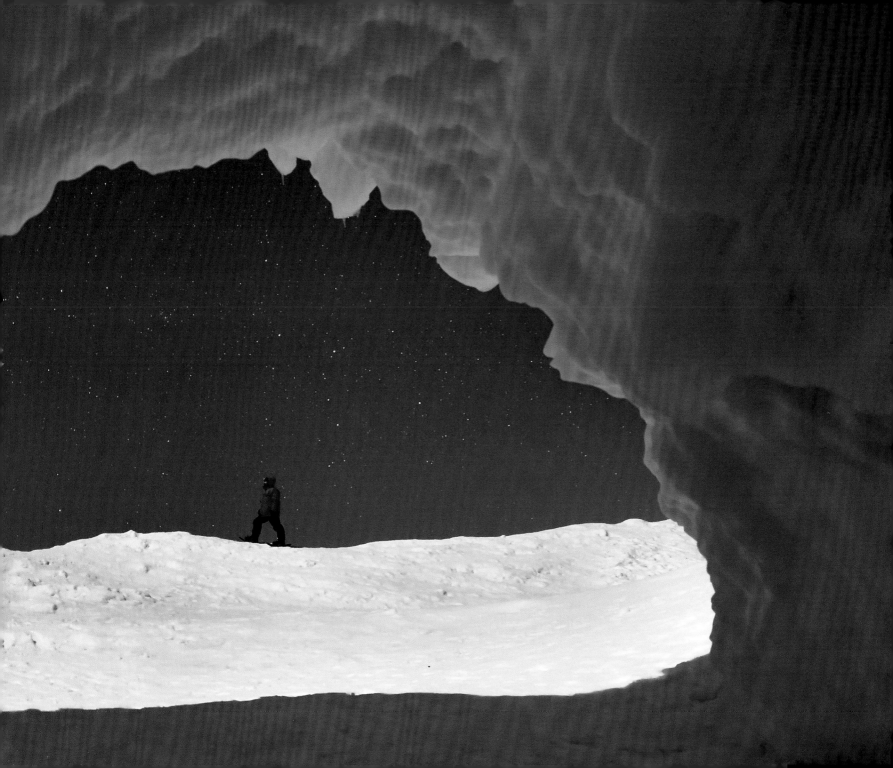

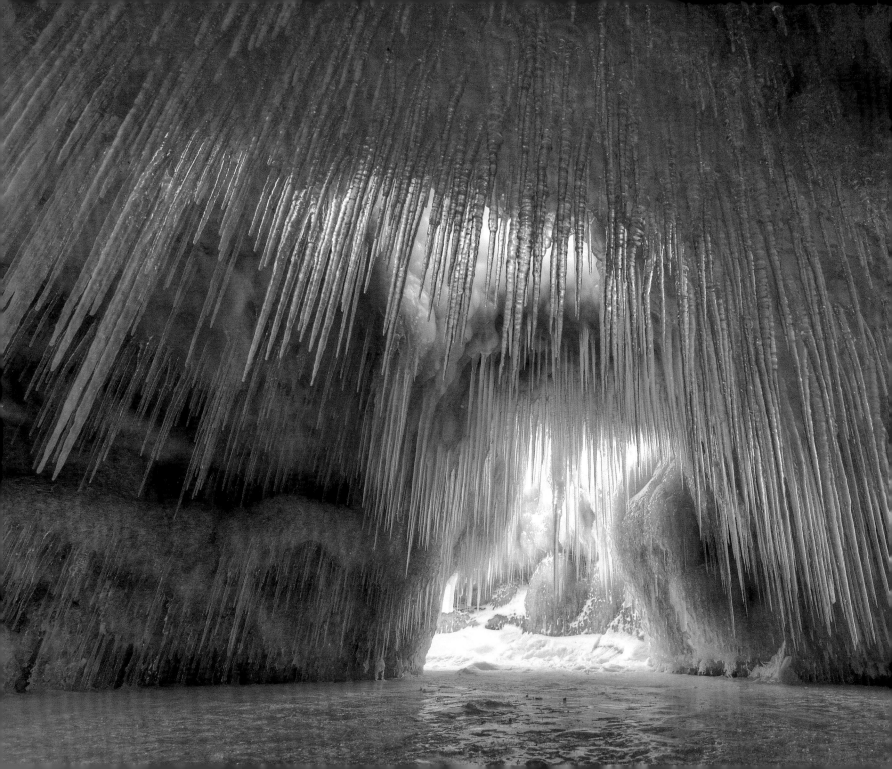

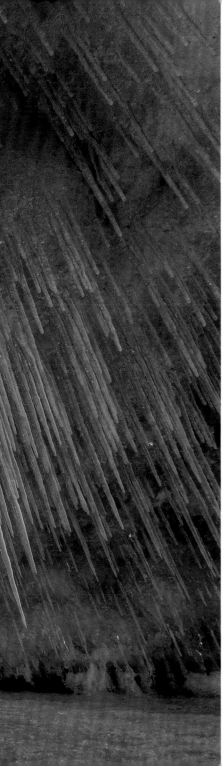

ICICLE FORMATIONS

Icicles hanging from the roof of the ice caves look like stalactites seen in regular caves. They grow downward the same way stalactites do as water drips from their ends. However, there is one missing ingredient; the sediment that forms the hard structure of the stalactites. This explains why there are no upward growing stalagmites on the ice floor of the cave, where the dripping water freezes into a flat layer of ice.

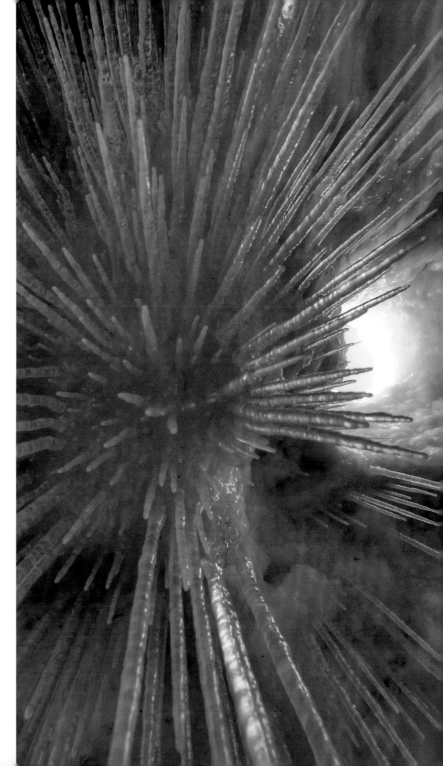

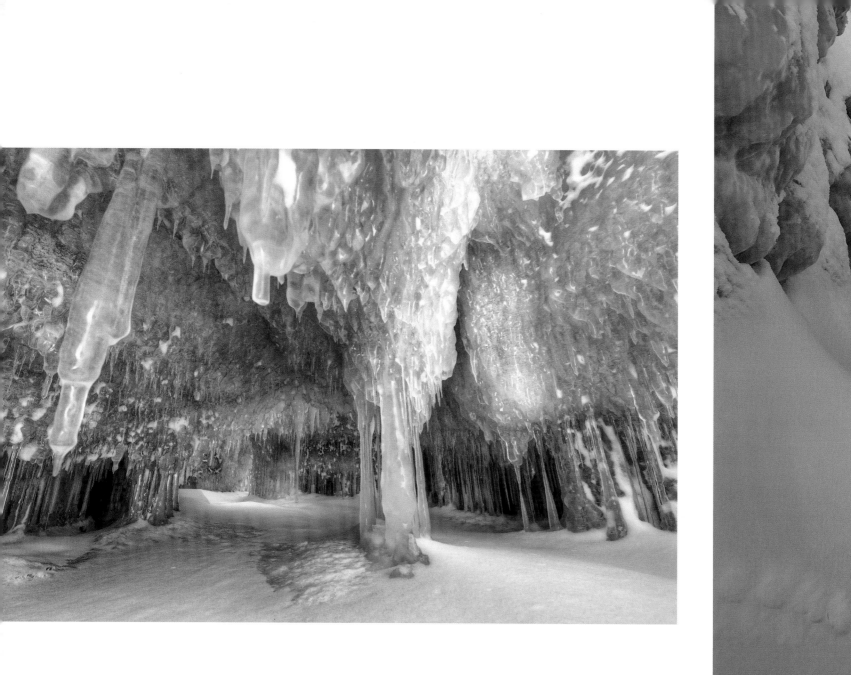

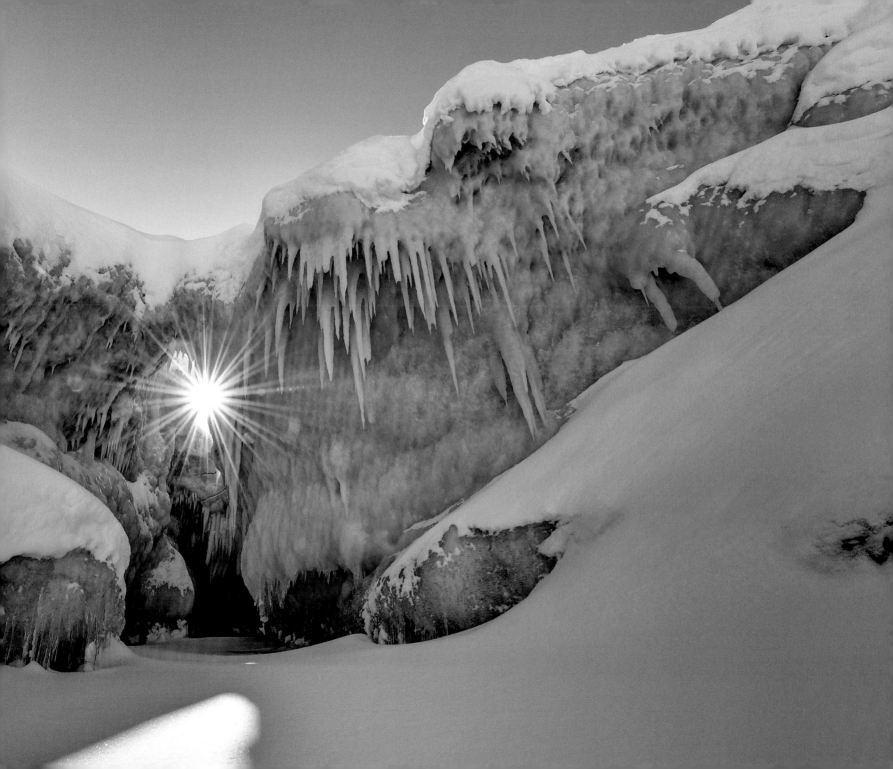

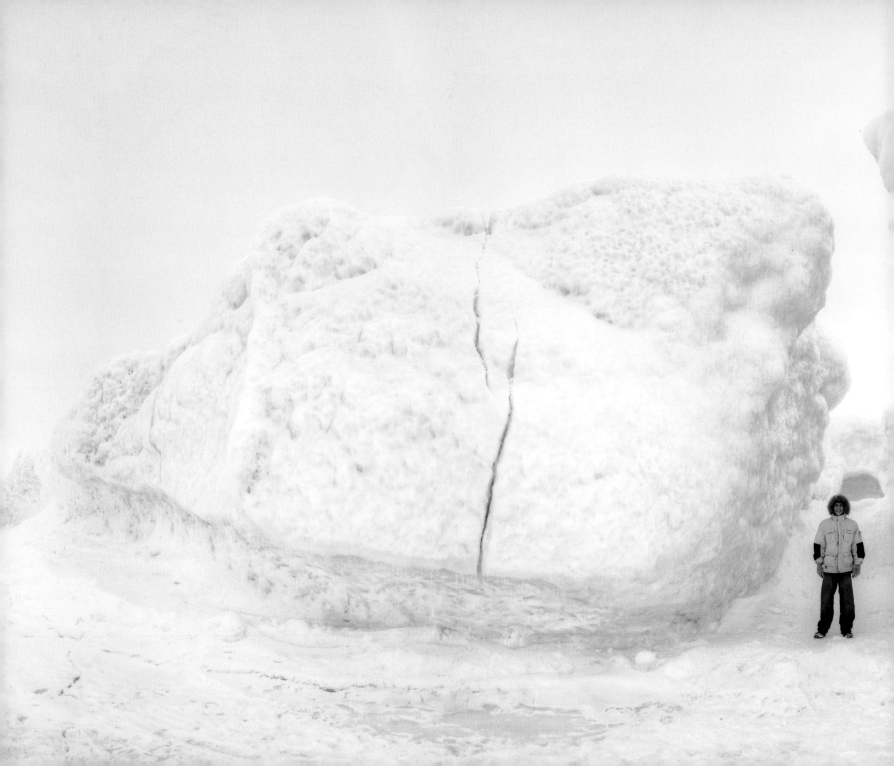

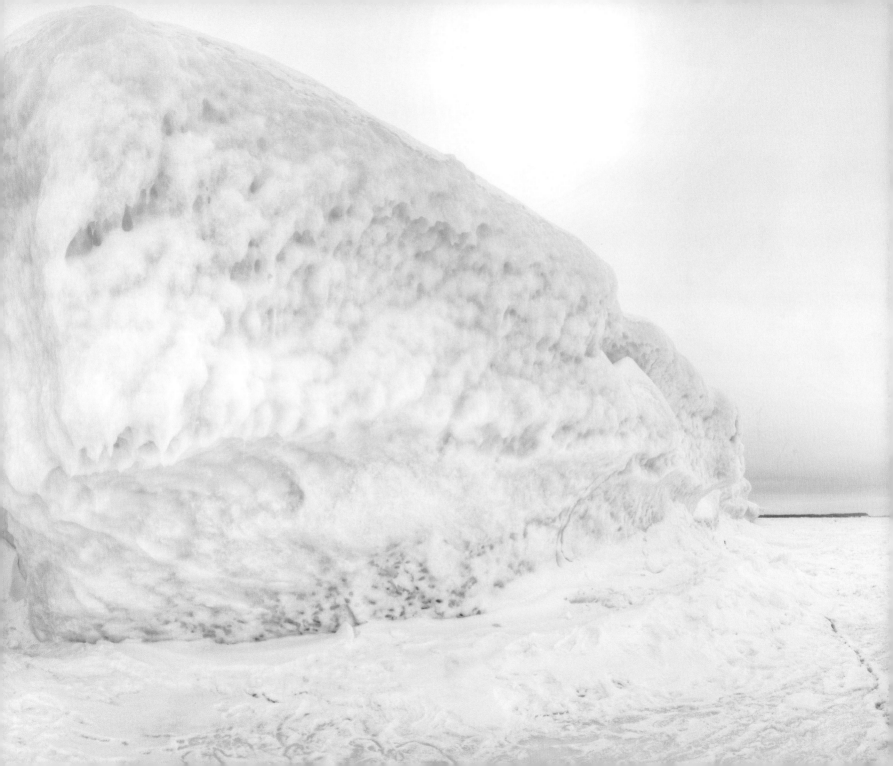

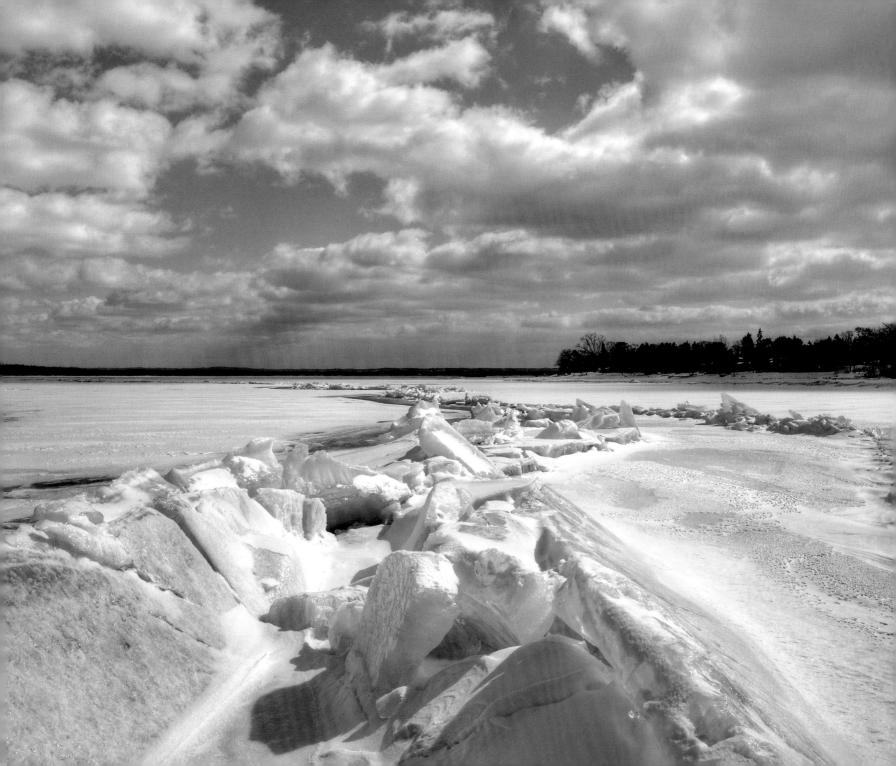

BLUE ICE, PRESSURE RIDGES, AND ICE PUSH

Ice weakly filters light. It removes red light while transmitting the shorter blue wavelength, so thick chunks of pure ice will appear blue. If there are some air bubbles suspended in the ice, more light is scattered and the ice appears greenish. If there are a lot of air bubbles, the ice appears white as all visible wavelengths are scattered.

Pressure ridges are formed where winds generate currents that break up the floating ice into sections that are then pushed together until the ice at the edge of the two sheets crumples and piles up. This is similar to how mountain ranges are formed by plate tectonics.

An ice push occurs when floating ice is pushed against a barrier such as a shoreline and piles up there. The photo on the following spread shows an example of an ice push.

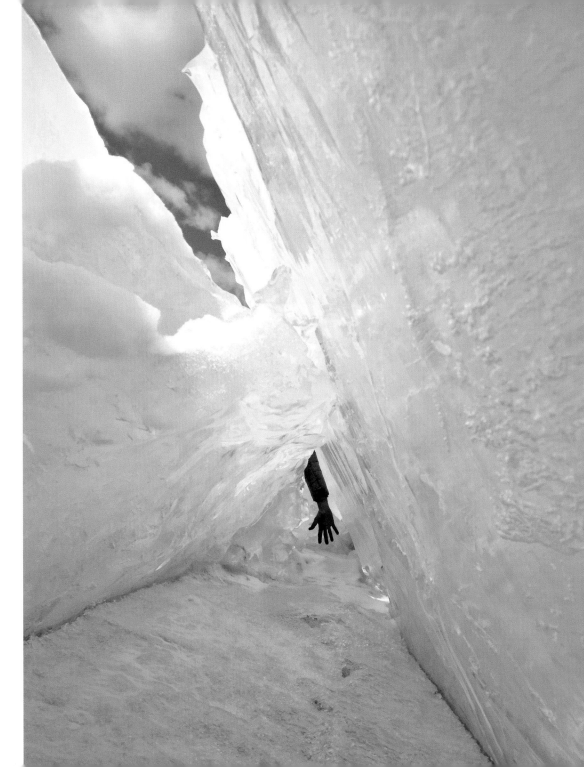

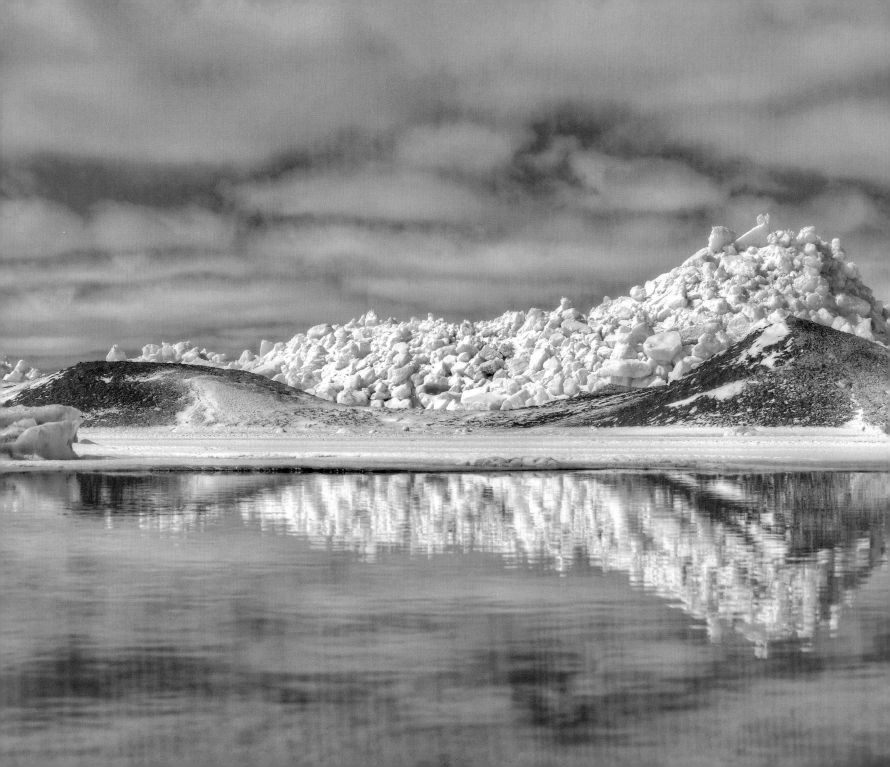

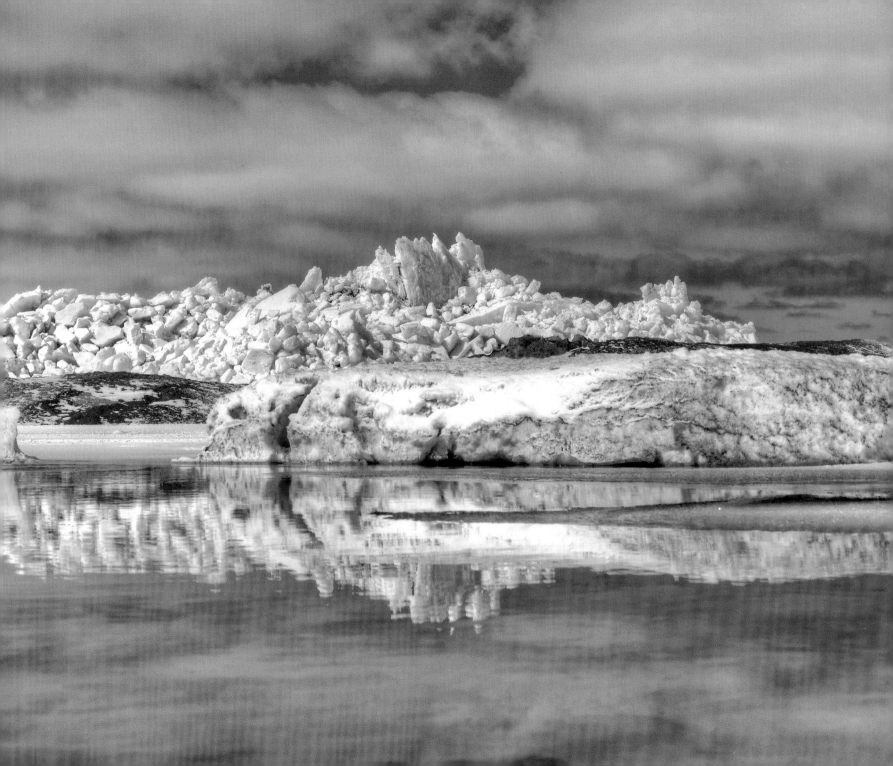

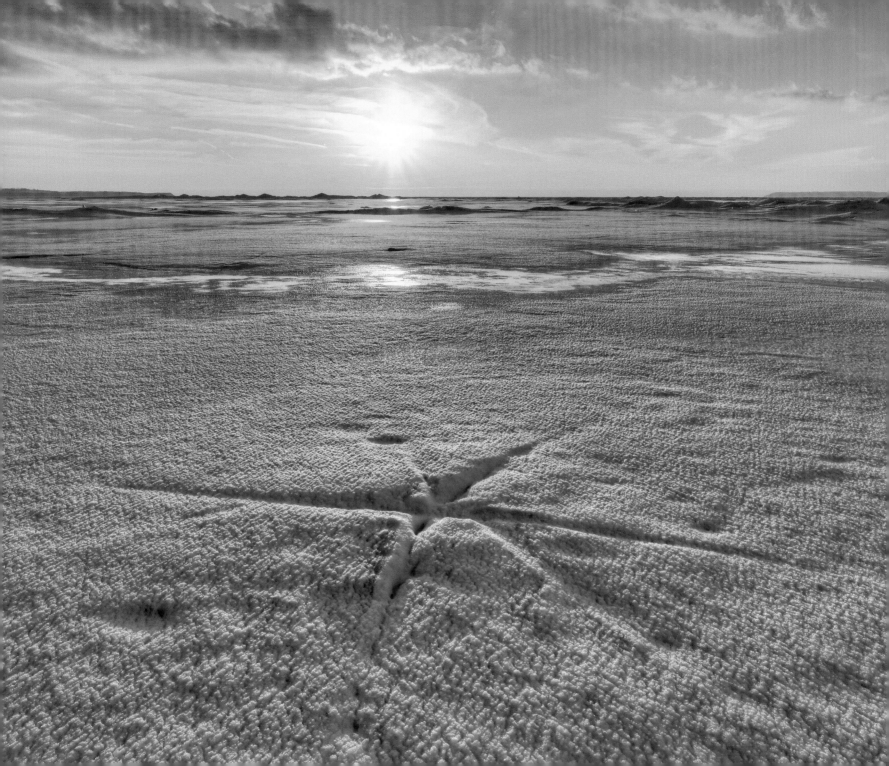

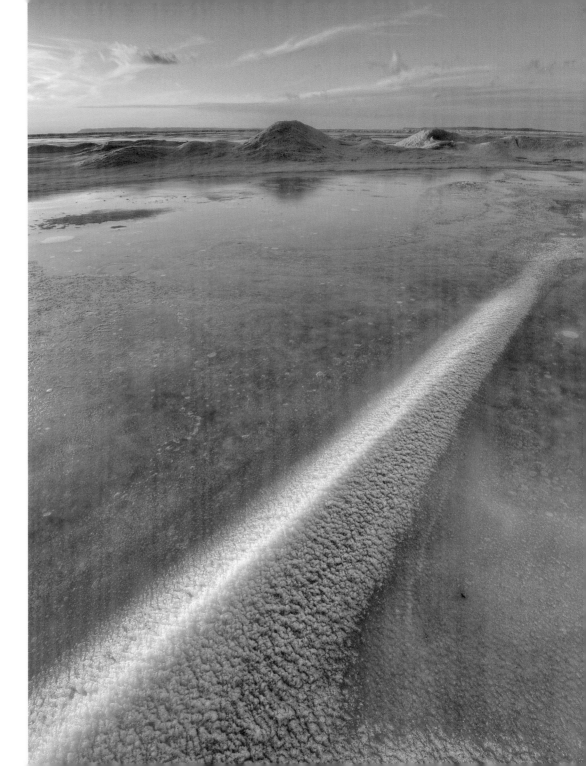

FISSURES IN THE ICE

As water levels change during the season sometimes a sheet of ice is left resting on a large rock, breaking into a perfect star pattern as in the photo on the right.

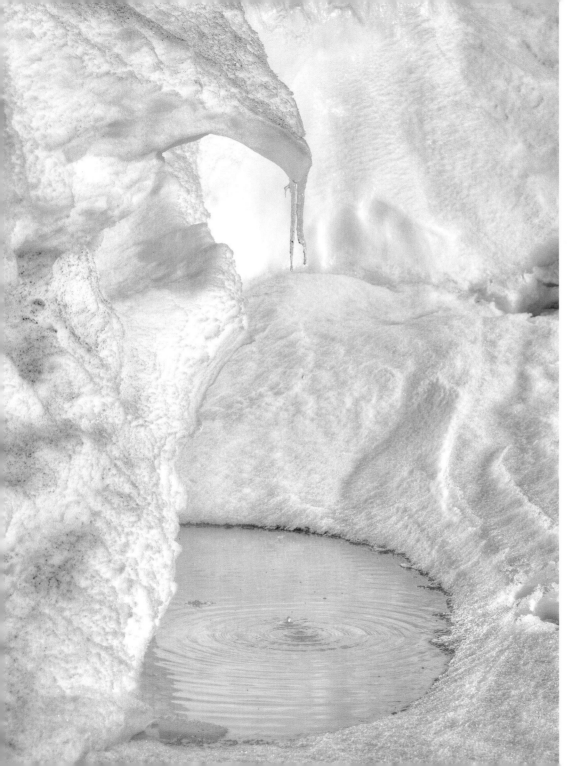

WINTER THAW

The anchor ice begins the slow melt in late winter and spring, forming melt pools that thaw and refreeze many times before finally becoming open water. These photos show early melt stages.

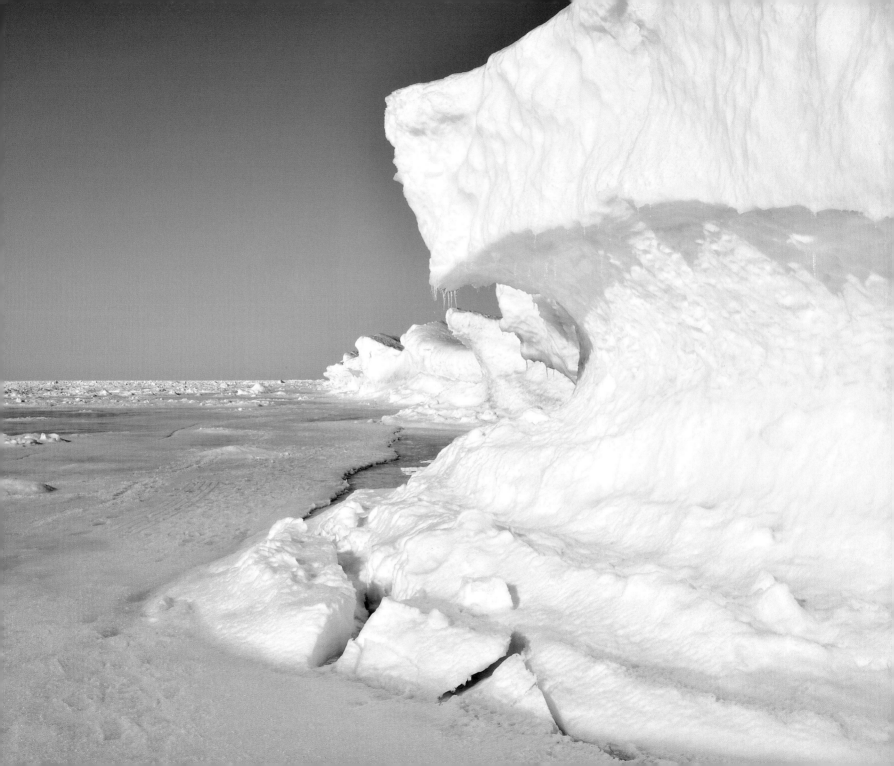

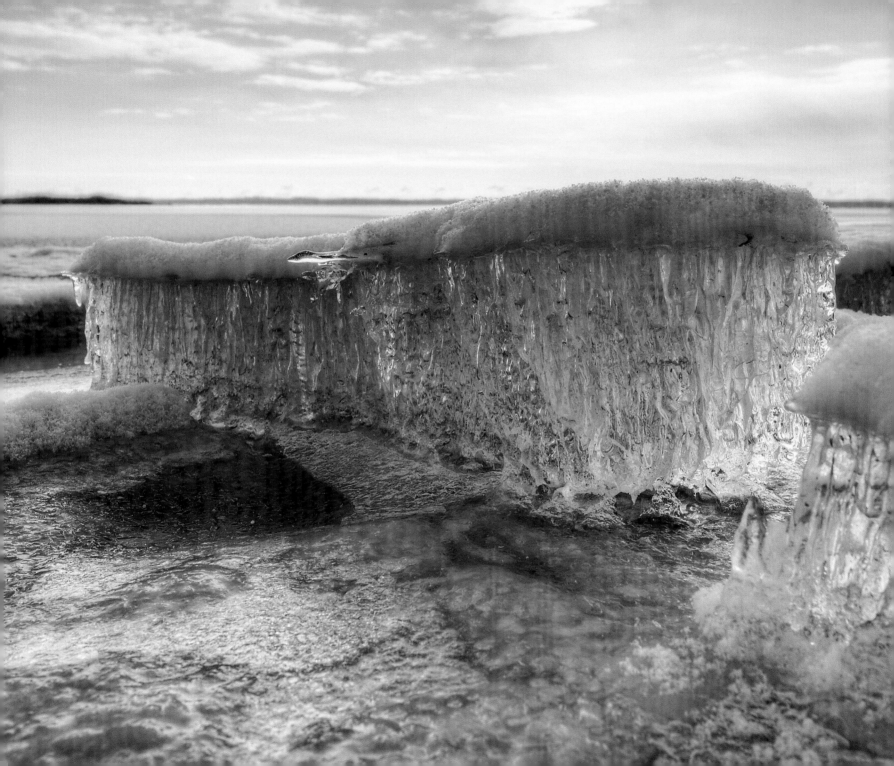

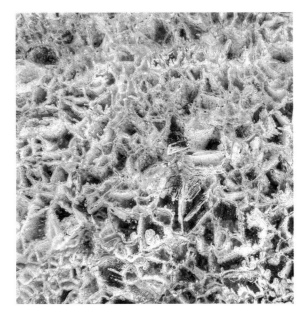

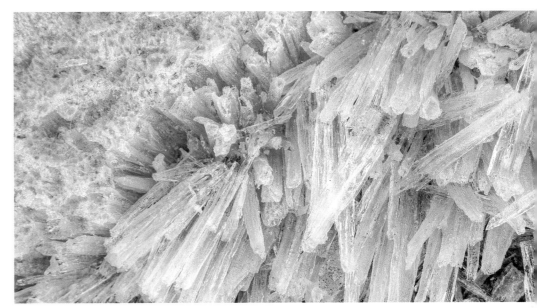

CANDLE ICE

The lake ice undergoes changes in the spring due to thawing and refreezing cycles. Perpendicular to the surface of the ice, honey-combed or tubular columns form from the refreezing of melt water. Candle ice is particularly beautiful as it disintegrates, clinking as it breaks apart and scatters.

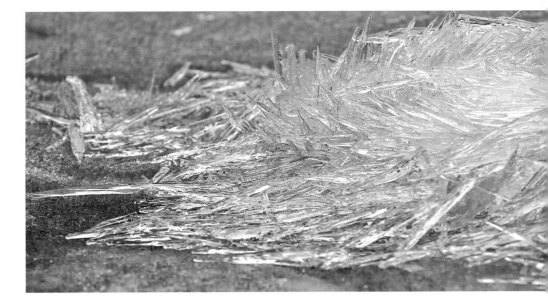

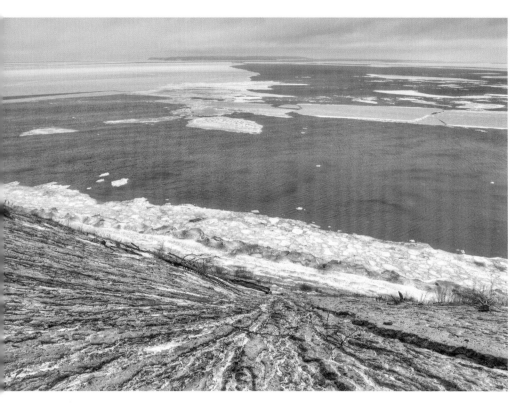

PYRAMID POINT THAW

A big snowstorm in February 2014 brought strong winds and powerful currents that shattered the floating pack ice. The photo on the right shows chunks of ice piled in a series of pressure ridges. This is where the edges of floating ice collided as they were pushed together. On the left, Pyramid Point dune shows the effect of a winter thaw. Narrow valleys were eroded in the sand and clay by melt water, and then refroze. These photos show how pack ice is constantly changing and being moved around, while the mounds of anchor ice stay put.

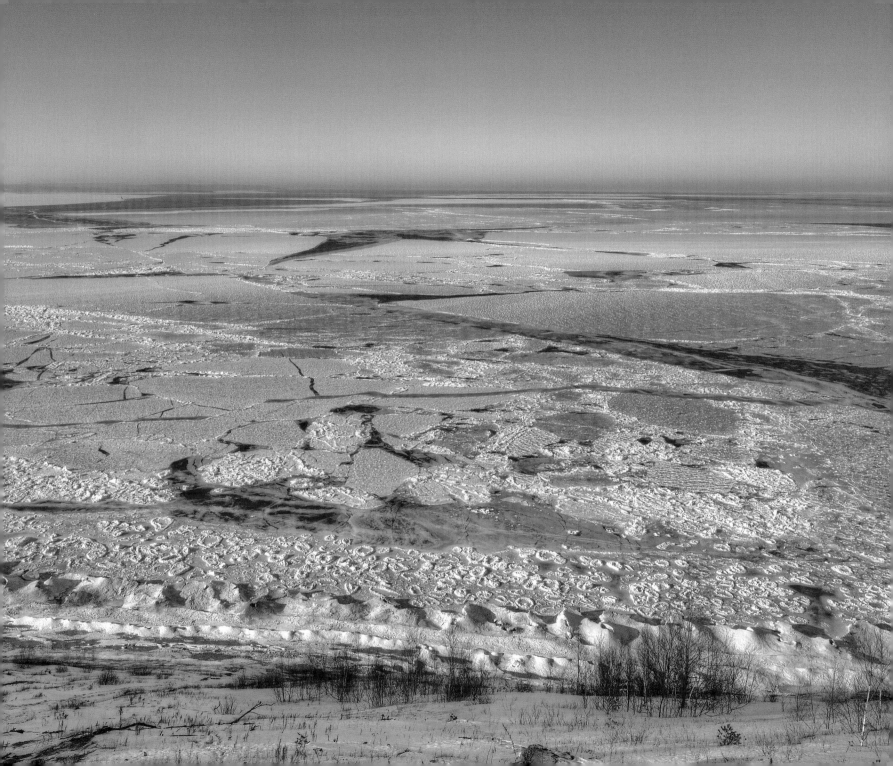

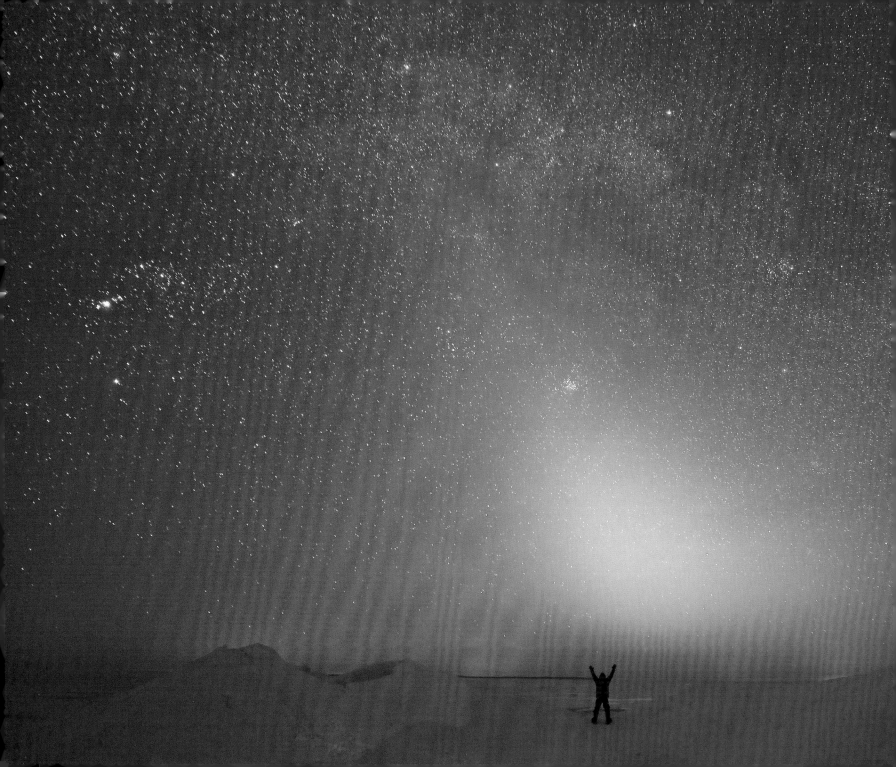

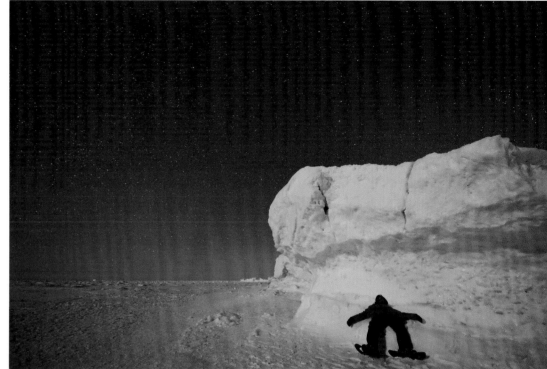

ZODIACAL LIGHT

The stars of Orion and other constellations shine above the ice caves on a night in March. Zodiacal light, seen in the photo on the left, is sunlight reflecting off small dust particles in the orbital plane of the solar system and is best seen in spring and fall, signifying the change of seasons. It appears as a faint, diffuse, white glow when the zodiac is at a steep angle to the horizon. It is very difficult to see when moonlight or light pollution is present.

Photo on right is Ken taking a break during a moonlit night shoot in near -10 degrees Fahrenheit.

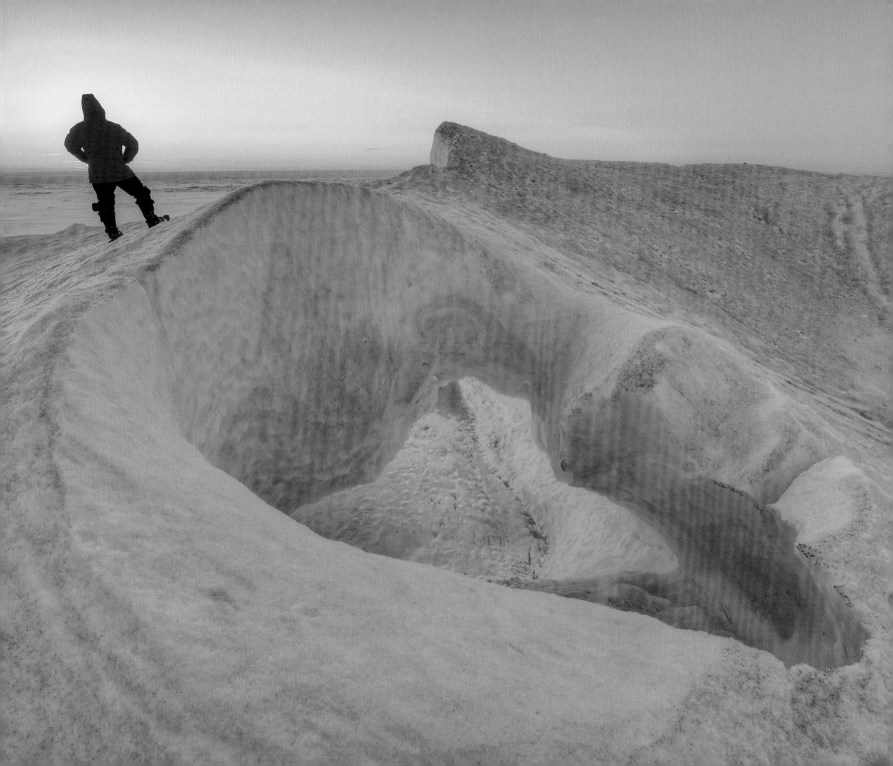

ELEGY FOR THE ICE

The spring of 2014 continued to be much colder than normal, allowing the great volume of ice built up over the winter on the Great Lakes to set records for coverage through the month of April. Despite the relentless bouts of cold, the ice eventually fell victim to the simple rhythm of Earth's inclined orbit around the sun. It was a long thaw before the caves, along with the volcanoes, balls, and pancakes, rejoined the rolling waves and deep currents of Lake Michigan. Ice, in all its glorious forms seen on and near Lake Michigan, is fleeting, even in the coldest of winter seasons.

Tourists from near and far will visit the lake in the summer and never imagine the frozen vistas that existed only months before. This ephemeral nature adds to the icy mystique. While limestone caves evolve over tens of millions of years, the ice caves of 2014 lasted mere weeks.

The photos in this book serve to preserve what was there and tell the story of how it formed, evolved, and then disappeared. It also calls us out of our hibernating comfort zones and into the bitter winds and stinging snowflakes to experience them in all their glory when the sun sinks low, mighty Orion and the constellations of winter rise high, and the ice forms again.

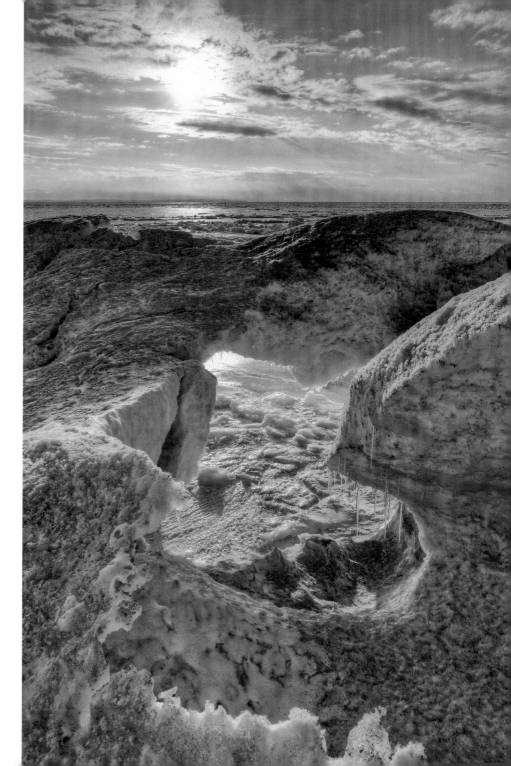

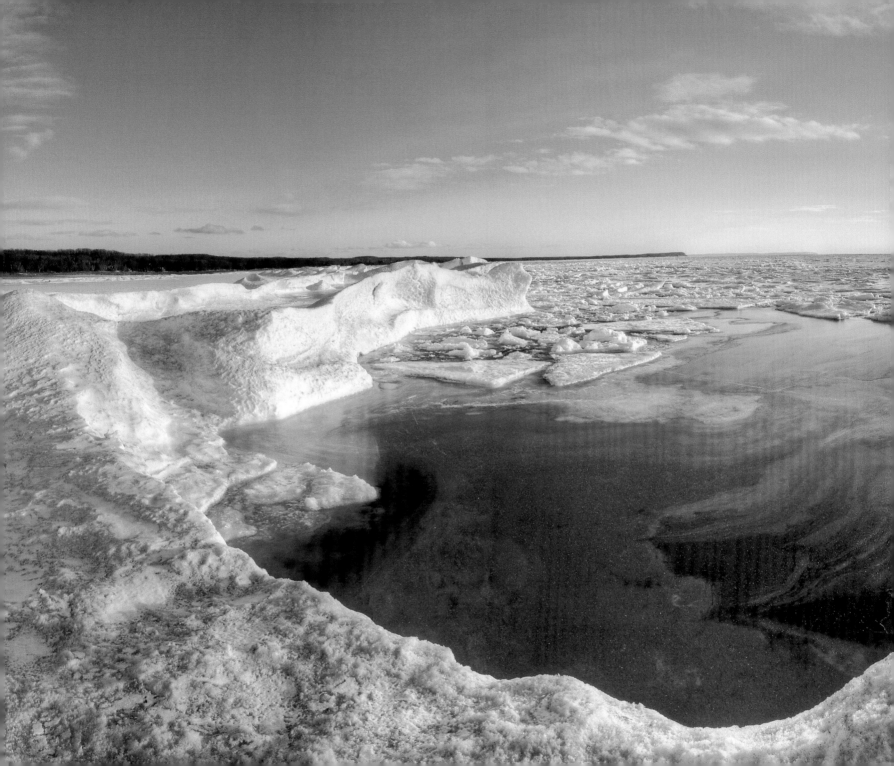

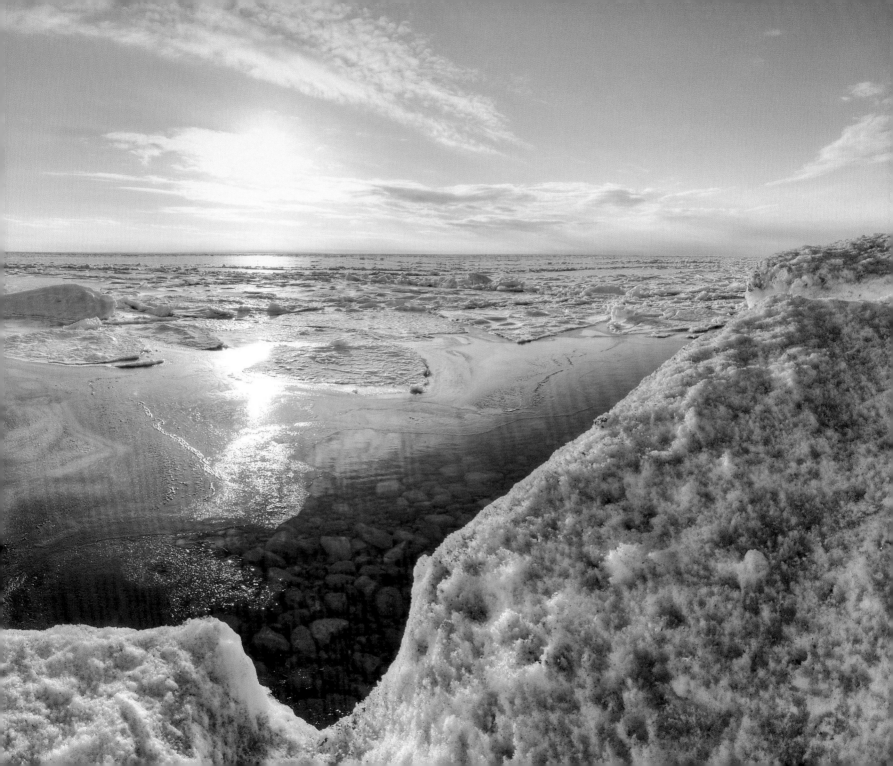

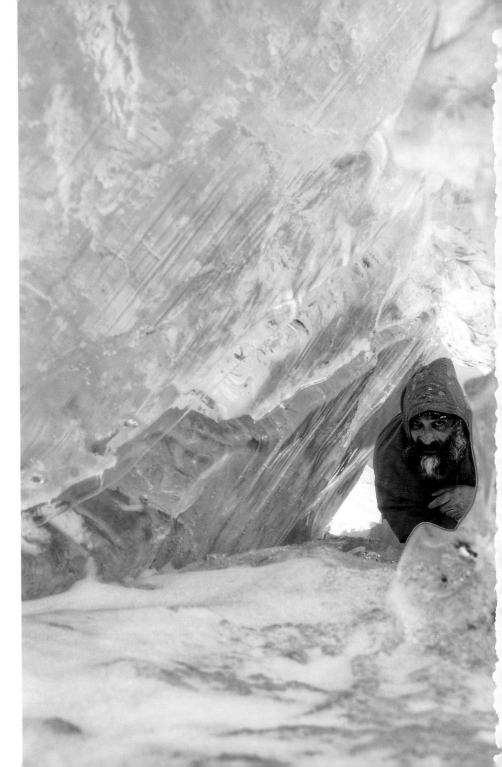

KEN SCOTT, the quintessential photographer of Leelanau County, captures the heart and soul of this beautiful place in his amazing images. On his long rambles through the county's landscape, he observes and patiently listens to nature, catching unique moments in the natural world as they are revealed. Ken is self-taught, and has adapted fluidly to changing photographic technology and techniques over his decades of work. Ken has become a local icon whose following continues to grow.

He has produced five books of images of Northern Michigan, and his photographs adorn the walls of Leelanau County lovers far and near. Ken is currently represented by Two Fish Gallery in Leland, Michigan Artists Gallery in Suttons Bay, The Bookstore in Frankfort, and The Cottage Book Shop in Glen Arbor. Images contained in this volume and more can be viewed at:

KenScottPhotography.com/ice

Ken dedicates this book to the Up North winter enthusiasts in all of us … or we go nuts! He also acknowledges the assistance of Barbara Siepker, Angela Saxon, Jerry and Gail Dennis, Ernie Ostuno, Corrina Leete, Brian Chamberlain, Kaye Krapohl, Ariadne Blayde, Trevor Scott, Jane Scott, Jason Hamelin and Danny Merchant.

48